Brice Marden Drawings

The Whitney Museum of American Art Collection

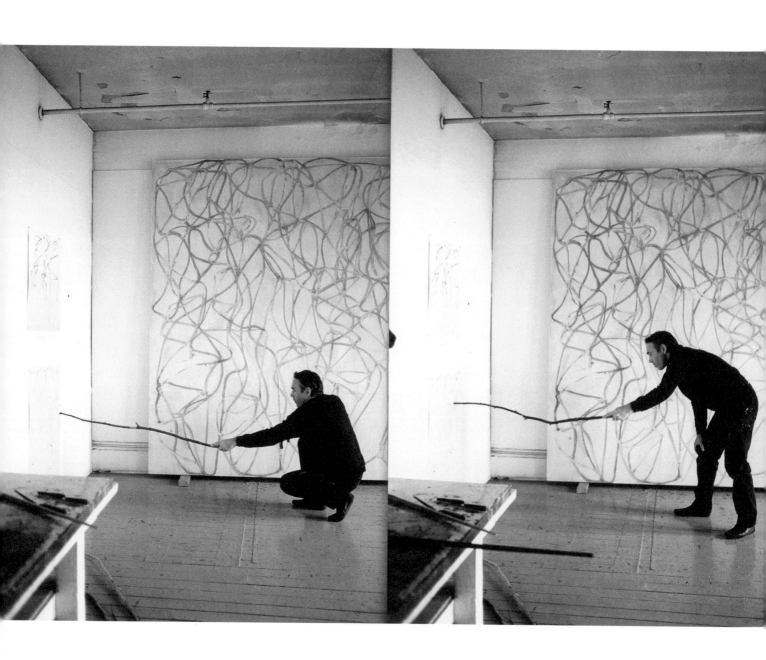

Brice Marden Drawings

The Whitney Museum of American Art Collection

Janie C. Lee

Whitney Museum of American Art, New York

Distributed by Harry N. Abrams, Inc., New York

This book was published on the occasion of the exhibition
"Brice Marden Drawings: The Whitney Museum of American Art Collection,"
November 20, 1998 – March 28, 1999.

THIS PUBLICATION IS MADE POSSIBLE BY GENEROUS GIFTS FROM THE DRAWING COMMITTEE OF THE WHITNEY MUSEUM OF AMERICAN ART.

RESEARCH FOR THE PUBLICATION WAS SUPPORTED BY INCOME FROM AN ENDOWMENT ESTABLISHED BY THE ANDREW W. MELLON FOUNDATION AND OTHER GENEROUS DONORS.

Cover; pages 9 and 12: Brice Marden's New York studio

Frontispiece: Brice Marden in his New York studio

The photographs of Brice Marden and his studio were taken in 1992–93 by David Seidner.

Contents

Foreword

Maxwell L. Anderson
Director

A museum's greatest privilege is to celebrate the oeuvre of an accomplished artist with its own holdings—particularly when the collection is enriched by gifts from the artist. The Whitney Museum of American Art is honored to present in this exhibition the drawings of Brice Marden in our care. Any aspect of Marden's contributions to twentieth-century art is deserving of tribute. But his drawings are especially revealing about his method and concerns, and bear scrutiny from several vantage points. In Janie C. Lee's thoughtful interview, Marden explores the interplay of technique and subject matter, and considers how he would assess his achievements today. In the course of his career, he drew inspiration from both nature and the man-made. What at times appears to be automatist in Marden's work is in fact a personal narrative informed by sources as diverse as kitchen tiles, Chinese character writing, and the rugged landscape of Greece, with an ultimate return to the human form. This varied diet produced an equally rich and textured body of work, free of the constraints of pure figuration or pure abstraction.

Marden is explicit in this latest interview about his dogged pursuit of a satisfactory drawn surface, which he admits reached a point of tedium, but a reassuring tedium akin to that brought on by meditation. The prolonged process of addition and erasure set him apart from Minimalist contemporaries, for whom the achievement of a distilled statement bearing no traces of human agency was often as not a primary goal. Marden's process also separated him from those earlier Action painters, such as Pollock, who found greater expressive potential in the chaos of form. Like any artist describing a personal technique, Marden startles us with the extent to which simple technical constraints and discoveries affected the outcome—for example, his delight in Montblanc pens. He also found in postcards of Old Master paintings and architectural monuments easily transported aide-mémoire which, when reduced to part of a prepared surface, provoked a wealth of associations.

This century's attention to the process of artmaking often strikes us as novel. In point of fact, the deliberations that led Marden to conquer one obstacle or another are reassuringly familiar. The very act of drawing has been, since the invention of paper, an intimate pact between artist and support to explore

6

ideation and form. The medium in which Marden has carried out these explorations has historical antecedents in the use of beeswax and encaustic. Marden adds a new level of inspiration through his meticulous and nuanced activity of narrative, unfettered by the received wisdom of a prevailing school or movement.

In the current exhibition, Marden rewards us through the sensuality of his drawings, as he does in this publication through his matter-of-fact but illuminating account of the working method that led to them. We are forever indebted to him for his donation to the Museum and for his implied faith in our ability to do justice to his oeuvre. I would also like to thank Janie C. Lee for overseeing this project, and the members of the Drawing Committee for providing the generous support necessary to acquire the drawings and produce this catalogue.

The Whitney Museum intends to add to its collection of works by Brice Marden in the years to come, and hopes to be the preeminent resource for the study and appreciation of all that he achieved. This publication should therefore be seen as the most recent in a series of efforts to champion Marden's achievements and make them available and accessible to a new generation of admirers.

Acknowledgments

Janie C. Lee
ADJUNCT CURATOR, DRAWINGS

In 1997, the Drawing Committee of the Whitney Museum of American Art embarked on a project to collect Brice Marden's drawings in depth, building on the two exceptional drawings already in the Museum's collection. "Brice Marden Drawings: The Whitney Museum of American Art Collection" recognizes the mutual commitment Brice Marden and the Whitney have made and celebrates the outcome of this collaboration.

Working with the artist, the committee acquired nine large major drawings from different phases of Marden's career. In addition to the acquisitions, the artist gave seven major drawings and a workbook. This is the first time Marden has made a donation of drawings to a museum, and the Whitney now holds the largest collection of Marden drawings in the world: fifty-two works—eighteen drawings and a workbook containing thirty-four sheets.

This group represents a beginning, not a conclusion. Our goal is to build on this collection with acquisitions of future Marden drawings as well as selections from earlier work.

I would like to thank Murray H. Bring, chairman of the Drawing Committee, and all the members of the Drawing Committee for their enthusiasm and support. I would also like to thank Leonard A. Lauder, chairman of the Board of Trustees, David A. Ross, former director, and Maxwell L. Anderson, director, who have all believed in this project. I am also grateful to Matthew Marks and his gallery staff for their assistance, to David Seidner for his photographs, and to Arnold Glimcher. Finally, I am deeply indebted to Brice Marden for the generosity of his magnificent gift to the Whitney, and for the time and patience he has given to this project.

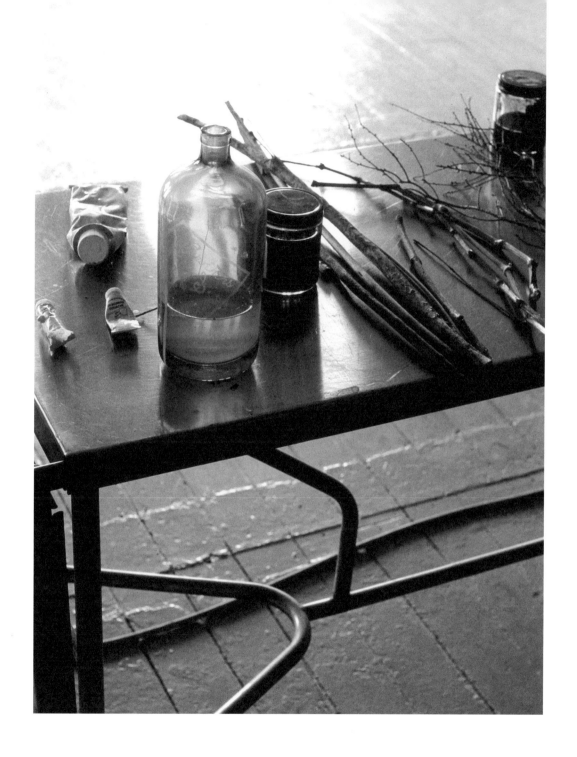

Introduction

Janie C. Lee

To be a great draftsman, an artist must regard drawing as crucial to the creative process. Like Willem de Kooning and Jackson Pollock before him, Brice Marden loves to draw and has used his drawings throughout his career to study and develop ideas. All three artists, moreover, engaged their arms and bodies as well as their hands to give each line of their drawings immediacy and energy. For Marden, in the 1960s and 1970s, this meant going against the Minimalist precept that all traces of the "hand"—all marks of the artist as individual—be eliminated. This Marden could never do, because he was, at heart, a draftsman.

Born in 1938, Brice Marden graduated from Boston University in 1961 and Yale University School of Art and Architecture in 1963. He spent the summer of 1964 in Paris, where he began to make carefully measured drawings of grids. Although Minimalist in format, the grids were drawn in charcoal, which produced a warm, sensual surface.

Upon returning to New York, Marden explored another format—solid graphite rectangles placed on pristine white sheets. Again the result was not stark Minimalism, for the rectangles were composed of many layers of graphite that had been sanded down after each application to yield a rich, dense skin. Sometimes the graphite rectangles stood alone; sometimes there were more than one on a sheet.

In the early 1970s, Marden started two series, *Homage to Art* and *Souvenir de Grèce*, in which he combined postcards of art works or architectural monuments from Greece with graphite grids or solid graphite rectangles. With a razor blade, he scraped out the paper where the postcard was to be inserted so that the plane of the thick paper would remain flat. Of pivotal importance to Marden in these works was the proportional relationship between the host sheet, the graphite area, and the postcard images. Other changes were also evident in Marden's work at this time. In the series of ink drawings entitled *Suicide Notes*, the solid form began to fracture and break apart, which broadened the expressive possibilities of Marden's art.

In 1973, Marden set aside his pencils and pens and began to draw with sticks made from tree branches dipped in ink. These sticks became Marden's primary

drawing tool. His first efforts with this novel instrument were grid-format drawings whose lines looked like conventional penwork. Within a few years, however, the line underwent radical alteration: unlike the early stick drawings, whose lines are taut, the line in the two series of drawings Marden made for his daughters (*Mirabelle*, 1978–79 and *Melia*, 1980–81) is full of movement and expression.

Throughout his career, Marden has used workbooks to record ideas and images for future reference. These books travel with him and serve as a journal of his thoughts. Thus, when in 1974 he began to travel extensively in Greece and on the Greek island of Hydra, his workbooks reflect not only some early calligraphic concepts, but thoughts about how to translate the mountains, sea, and light of Greece into his own visual vocabulary.

Marden has long admired Chinese calligraphy, and in the 1980s calligraphy became foremost as an influence on his work. Sometimes the calligraphic line merged with imagery adapted from markings on seashells or the movement of leaves. While the result was always abstract, nature remained central to Marden's conception.

In addition to observing Chinese calligraphy, Marden also studied Chinese poetry. In 1990, he began a series of drawings and paintings entitled *Cold Mountain*, the translated name of one of his favorite Chinese poets, Han Shan. In the drawings and paintings of the *Cold Mountain* series, Marden reaches a new level of maturity, bringing together the abstract with the spiritual. The paintings and drawings are deeply beautiful, full of mystery and light.

Marden began to spend time in 1995 in Eagles Mere, Pennsylvania, where he has a small studio. He recently embarked on a new series called the *Eagles Mere Set*, in which the image again undergoes alteration as the calligraphic presence recedes and a new gestural figurative form emerges.

In his thirty-year career, Brice Marden has changed the look of abstraction. Remarkably, he has done it not once, but twice: first with the solid forms of muted tonalities in the 1960s, and again with the calligraphic imagery that culminated in the *Cold Mountain* series. Viewing the works in this exhibition, it becomes clear that Marden's innovative concepts began and evolved through his drawings.

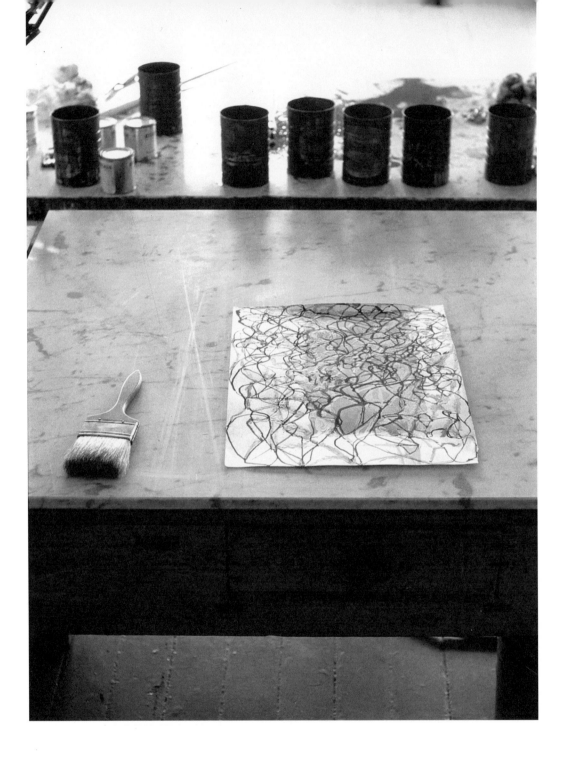

Interview with Brice Marden

Janie C. Lee
MAY 21, 1998

JL: Today we are sitting here at the Whitney looking at drawings from the Whitney's collection that you made between 1964 and 1997. I would like to talk with you about these drawings: how they were executed, what part they played in the evolution of your work, and their significance in the way you have changed the look of abstract art.

Two *Untitled* works, one of 1964, the other of 1968, are both grid drawings, but very different in feeling primarily because of the media. The 1964 drawing was done in charcoal, the 1968 drawing with beeswax, oil crayon, graphite, and pastel. Could you talk a little about the way you worked these two drawings?

BM: When I got to Paris in 1964, I couldn't paint because I didn't have a studio, so I worked on drawings, and I found that these drawings were continuations of the paintings I had been working on in New York, which had a large area of just gray. I felt that I wanted to break the gray area down to make it tighter and have the surface be more taut, and so I started using a grid. The grid actually began from a frottage I did of the tiles in our kitchen. I started working on this grid drawing in Paris and then brought it back to New York and reworked it there. I was using compressed charcoal.

JL: Why did you use compressed charcoal?

BM: It's a heavier and greasier charcoal, so you get a denser black and I could work blacks over blacks. You can erase it and get a range of grays. It's more controllable than, say, vine charcoal. These drawings were the very early ones—there are only a couple from 1964—and I sanded them. I would build up certain colors and then I would want to take it back down. So I would sand it; that's why you have holes in the sheet. Well the 1968 grid, I went over that grid with oil crayon. Then I rubbed oil crayon into the graphite, so that's how you get the surface.

JL: The *Two Studies*, *Back Series* of 1967, among many other drawings, shows the incredible graphite surface that you can create. I hesitate to ask this, but about how much do you have to work to get that density of graphite?

BM: Well, you have to work it a lot. There was a tedium in working the drawing. It was almost meditative. This *Back* drawing is on a piece of 300-pound Arches Torchand paper, which is a textured paper. I would sand down the graphite area in the rectangle. Then I would scrape it with a razor blade, smooth it out. Then I would rub beeswax onto that surface, and then scrape the beeswax down with the razor blade, just to get a smooth wax surface—not a heavily built-up one—so that when I applied the graphite, there wouldn't be texture.

JL: In the *Back* drawing, there are literally two large rectangles of worked graphite surrounded by the paper. So the result is dark, solid, smooth graphite surfaces contrasted with the texture of the paper. But you would have the contrast with the texture on the outside of the rectangle.

BM: I was turning a piece of white paper into black. And basically to do that, you just have to keep going over it and over it and over it and over it because you have to fill in all these tiny little holes in the paper that are white. And you're also mixing the graphite with the beeswax, so that in a way the graphite is like a paint pigment with the wax as the binder. And then you have to make sure it's even. You have to work at it. I would have a hard edge, like a metal ruler, and I would work out to the edge of the rectangle with that. It's a long, tedious process. The *Back* series was done I think with 4B graphite sticks. Koh-i-noor graphite sticks. I used a harder one and a softer one. And on the softer one, you had just the softer grade of graphite and you got a completely different look to the drawing.

JL: Let's move on to the *Suicide Note* over there. The *Suicide Notes*, which you began in 1972, are full of exploration and new beginnings.

BM: I think they were started on the new year, on New Year's Day.

JL: I wanted a drawing of this nature in the Permanent Collection because I think that the *Suicide Notes* really show the beginning of a whole new movement of your hand.

BM: They're another exploration of space in relation to surface.

JL: But they're totally different from what you did before.

BM: It was also the fact that I had discovered Montblanc fountain pens—which really draw. They're very good pens—it was like a blessing. They were very portable, which meant you could work with high quality pens anywhere, and you could take a notebook anywhere, so you always had your supplies with you to set up.

JL: 1972 is the beginning of the *Homage to Art* drawings, which are again a completely different series. These drawings are composed of graphite and carefully selected postcards of art by artists such as Goya, Mondrian, Fra Angelico, Zurburán, and others whose art you admired. The only twentieth-century artist that you selected in the group was Mondrian. Why did you select Mondrian's *Broadway Boogie Woogie*?

BM: There was a period when I would go to The Museum of Modern Art about once a week to look at that painting. It was really influential. I was studying that painting. And I made the drawings after that.

JL: How is your grid worked in relation to the Mondrian?

BM: It has some relation to it. I kept taking it down and making it smaller, the grid finer and finer, to have some relation to the Mondrian, but it doesn't have a relationship to the real Mondrian. It has a relationship to the postcard reproduction of it.

JL: It's interesting how the postcard has been placed on the drawing. It appears as if it's almost set in, so that the plane of the work is maintained.

BM: I would scrape out an indentation in the paper with a razor blade and place the image in the paper so that the surface remained even. It was a time when there was a lot of emphasis on collage with Johns and Rauschenberg, and this was my response—my idea about the plane. I thought of those drawings as sort of expositions on the plane. It's this whole idea of a plane and the image. One of the things I think about is that the artist is some sort of intermediary for the image. The process is really about feeling and trying to understand what's out there and how you're responding to it and getting it down so it can be communicated. The plane at one point is chaos or the miasma, and you work it up just so that there's an image. The chaos becomes understandable, or

you can see it in some way that isn't necessarily understandable, but it's plausible. You have to make some form out of it. And you're just a sensitive being and you helped evolve that form. I think if there's a real working idea for me it's letting the image come up out of the unknown rather than taking some known thing and applying it to the plane and defining it.

JL: Returning to the *Homage to Art* series, 1972–73. Can you compare it to the *Souvenir de Grèce* series, which you began in 1974 and completed in 1996? Would you talk about their similarities and differences?

BM: The postcards in the *Homage to Art* series were collected highlights of museum visits. So they were all pieces that really meant something to me. The *Souvenir de Grèce* had to do with a postcard I found in Greece that had all these little photographs of famous monuments and sites. I bought a lot of these postcards, cut out all the individual little scenes, and then I would make compositions, some based on the composition of the photograph and some loosely based on it. So they became much more compositional or arranged. Whereas in the *Homage to Art*, it was really more about this idea of the plane and the image. I thought that the *Souvenir de Grèce* series was a little bit more playful. But as the works evolved, they really became much more of a statement of response to the Greek landscape.

JL: You continued to work on the *Souvenir de Grèce* drawings for a long time, until 1996. Were you actively working on them or did you set them aside?

BM: It was just so hard to get them right, scraping, figuring it out. Some I'd get figured out and then would make a mistake and have to go back and re-do the whole drawing. And other things became more pressing issues. Basically I kept them in a portfolio. But I had moved away from graphite into ink drawings. I finished them all by just very deliberately taking out the portfolio and really making a point of finishing them.

JL: You showed the *Souvenir de Grèce* series fairly recently as a group in Venice?

BM: They were all shown at the Biennale last summer (1997). It was interesting for me because it was Venice. I had the chance to show all the *Souvenir de Grèce* works, and I think of Venice as so closely associated with Greece. Installing

them was really great because they had this door open and you could just look out at all these olive trees. It was wonderful.

JL: What is the image in the Whitney's *Souvenir de Grèce 14* drawing?

BM: It's the Knossos palace of Minos in Crete. You can see that the composition of the drawing is taken from a suggestion of the image. I had done two drawings, *Hydra I* and *Hydra II*, that were this exact setup. They were black on the top and white on the bottom. For *Souvenir de Grèce 14*, I would take the physical border of the image from the deckle around the paper, do it on three sides and leave the bottom open, and I would make that shape. So there would be a shape that went from the bottom of the paper up to the lower edge of the top deckle or really the inside of the deckle. And I would halve that shape. And that became the horizon, and the top would be black and the bottom would be white. There were two drawings like that, and then I used those drawings as the basis for all the others. So each one is like a little temple in the landscape. Maybe that's a little too corny.

JL: Regarding *Untitled (Stick Drawing)*, 1974. In 1973 you started drawing with sticks instead of pencils or pens. If I hadn't been told, I would not have known this drawing was made with a stick. How did you do it?

BM: The early stick drawings are done flat down on a table and with a straightedge, a plastic straightedge that has a raised edge so the ink won't seep beyond the mark. It had a lot to do with just feeling out the surface. It's a refinement on the grid drawings.

JL: When you initially started to work with a stick, why did you select an ailanthus branch over any other type of stick?

BM: I was living on Bond Street in Manhattan. There were a lot of these trees in the backyard and they would just drop branches with all these little leaves that come off. And I always thought they'd make a really great drawing instrument because it's a very beautiful long stick. I was going to use the fat end and then when I started working, the ink wouldn't hold on that end, so I started using the other end. As you work you can break the end off when it gets worn down.

JL: In 1978–79 you created an incredible series of drawings done for your first daughter, Mirabelle. They are made of remarkably beautiful and sensual markings. How do the Whitney drawings fit into this group?

BM: Basically, they're addenda. There were nine left over from the original thirty *Mirabelle* drawings. The addenda set were drawings that didn't seem to fit into groups, and so I reworked them after finishing the *Mirabelle* drawings. I was able to make some of them more finished because I didn't have to relate them to a specific group.

JL: Do you use a particular ink with that kind of handmade paper? The merging of the ink and that paper is so beautiful.

BM: Well these are very sensuous drawings. They were done after Mirabelle's 2 am feeding and I was holding her in one arm, sort of lulling her to sleep, and drawing with the other hand. We were in a small room, like a closet or dressing room, and there was a whole thing about that. It's very physical. The paper is from India. The inked stick would respond to the texture of the paper and that would in some way dictate what would happen to the drawing. In the third drawing, I went back in really hard and then put on that black, which covers over something. But for the most part these were very sensuous responses to the situation. They're very kind of Rothko.

JL: The *Hydra Group X* drawing is from 1979–81. Were you working on this while completing the painting *Thira*, because they both seem to be dealing with architectural elements?

BM: The *Hydra Group* drawings are a little bit earlier. They were done on the Greek island of Hydra. I was looking at doorways and windows. They shutter the windows in a certain way on Hydra. I had taken a whole group of photographs of the windows and the drawings are loosely based on them.

JL: I particularly like this *Hydra Group X* drawing, because it almost looks, in a way, like a ruin of a doorway, with the paper-torn edges.

BM: It is very funky! We had a cistern cover. It was a squarish marble thing, very rough, not polished marble. I would just lay the sheets down flat on the

cistern cover and paint them, using straightedges and stuff like that. I had never really painted in Greece—this was the first time I painted in oils on really beautiful Japanese paper, which is very absorbent paper so it has a nice feel when you work on it.

JL: In 1984 you began to create an incredible new gestural imagery in your drawings. The major influences were Chinese calligraphy, nature, and the forms of seashells. This sentence makes the process sound quick and easy, but I am sure it was the opposite, for calligraphy in itself is so complex. In the drawings *St. Bart's 1985–86 N.Y. 1*, *St. Bart's 1985–86 N.Y. 2*, and *St. Bart's 1985–86 N.Y. 3*, it would appear that you have merged the marks on the surface of the shell with the vertical structure of calligraphy. Were you consciously merging these two forms?

BM: I had done a group of drawings from the markings on seashells. I started them when I was in Thailand in 1983, when I started collecting shells; for a long time I was really actively collecting seashells. I would pick them for the graphic quality of their markings—that's how I collected. It was purely visual. And then I would often just draw the marks I found on the shells. You hold the shell, and there would be a little mark and then you would just draw it as if you were doing a portrait of something. It's very interesting because all the marks are affected by the growth of the creature, so you get sort of involved in it—like how hot the water was on such and such a day or how many years the shell was forming.

JL: And the shells all have their markings on the outside?

BM: Yes. Like an exoskeleton. The whole history of the life is right there on the surface. These drawings were all started as individual sheets in a book. Then I took the book apart and started putting them together in different sequences. Some I reworked, putting two sheets on each page.

JL: Are you working right to left here and top to bottom?

BM: It's usually top to bottom. Top to bottom and across to the left. I was following the Chinese calligraphic method. It was easier for me because I'm left-handed, so if I work from the right to the left, I don't run the chance of smudging the ink or some marking. These were very early calligraphy-based drawings.

JL: Nature is very important to your work. In *Vegetation St. Bart's 1* of 1986 you have abstracted the forms of nature. It's almost as if you can feel the breeze coming through—it's so light and delicate. Was the drawing actually made outdoors?

BM: Yes, we stayed in a place where there was a really nice group of palm trees—a grove of palm trees—and I would go out every day and set up the drawing board and then just look up and then draw, in the calligraphic form from top to bottom, right to left. I would look up and I would get some sort of gesture in the leaves. *Bridge Study* of 1991 was also started at the same place as *Vegetation*.

JL: I find the *Bridge* drawings a masterful achievement in that they synthesize so much of what you worked on throughout the 1980s. Did you work on this *Bridge* drawing after you completed the *Bridge* painting or along with it?

BM: No, they were done simultaneously with the *Cold Mountain* paintings. One painting ended up being called *Bridge* and this drawing is a study for it. The bridge is the one that the poet Han Shan alludes to in his poems—the bridge you go across to meet the immortals. These had started the same way, based on the calligraphy, and then you just go on and on and on. And then there was an arched form going through it that happened in the painting and happened in this drawing.

JL: You continued to work on the *Bridge* drawing while you worked on the other paintings in the *Cold Mountain* series, which I find very interesting. There are a number of things about *Bridge Study*—and all the drawings in that series—that seem to sum up so much of the work that preceded them. The way a dancer, after much time and work, finally performs a dance in concert—the initial discipline of steps has been mastered, one adds music and poetry, a composer, choreographer, lighting designer, set designer—and now all is ready for the dancer. I feel that *Bridge Study* is like the performance in that it has so many elements coming together.

BM: What you are saying about *Bridge Study* and the *Cold Mountain* paintings tends to be the way I work. I will work along on certain ideas and then there seems to be a point where you try to sum up the ideas, to push them through

to some other point. These drawings are really worked over a long period.

JL: I am very moved by *Bridge Study*. It is not only a complex, finished visual statement which is quite beautiful, but there is something inside that seems to reach out to another dimension.

BM: I'm not going to object to that. At Boston University, we were totally in awe of New York and the New York art scene. We were in a very conservative art school and this guy shows up, a color and design teacher who had studied with Hofmann and Albers. He had had contact with the real New York artists, and one of the things he said was . . . these guys don't do finished drawings. There isn't a major artist in New York who really concentrates on making finished drawings. And that always stuck with me, the idea that you could make a finished drawing. It's one of the things I really liked about Jasper Johns, because here was a guy who came along who was really making finished drawings. The drawing stood as a statement. It wasn't just a study or something on the way toward something else, and so I've always had that in mind about drawing. A drawing is a complete experience in itself.

JL: Let's look at *Eagles Mere Set, 5*, the newest drawing from 1996. I see this drawing as evolving out of *Bridge Study* and that period of drawings, except here some of the forms are recessed and there is a very bold stroke coming to the front. Where does the title *Eagles Mere Set* come from?

BM: We have a place in Eagles Mere, Pennsylvania. My studio is in a little barn out there, and it took me a while to get working. I had one drawing that I kept working on each time we were there. One day I picked it up again and finished it. I had this whole batch of paper that was the same size, so I started a new drawing, and then I started more drawings. The whole thing became the *Eagles Mere Set*, but they don't have to stay together.

JL: Do you see the *Eagles Mere* works as beginning a new form?

BM: Yes, the image becomes larger and a little more focused, a little more figural. It's more figural because some of the shapes are more like heads, and the image becomes like a figure. I like this kind of ambiguity. You can read certain shapes together, then they start reading with other shapes and, in a way, it just keeps

moving. In the *Bridge* and the *Cold Mountain* works, the columns of characters started turning into something that was almost figural. Some drawings were more of an exploration of a kind of figural aspect. They're taller than they're wider. You can read them as figures.

JL: Whether you are in Hydra, Eagles Mere, or on a trip, you carry a notebook or, as you say, a workbook. The workbook in the Whitney collection has thirty-four sheets and was drawn in Hydra, Tampere, New York City, and Bucks County, Pennsylvania, in 1987 and 1988. Where is Tampere?

BM: Tampere is in Finland. I was in a government-sponsored show of American painting, and a group of artists went there. It was like a little junket or something. I did a lot of work in the hotel room. Workbooks are books I carry with me all the time, so when I'm traveling, I do a lot of work in them. I would say traveling is part of the subject matter. The Whitney book has paper that takes the ink very nicely.

JL: You continue to challenge yourself. You don't sit back and say "I've got that mastered and now I can continue to do it." It seems that once you've mastered something, you're more inclined to find another form of expression, take another risk, and that is unusual. Most people don't want to risk the possibility of failure to create something different from what's been expected of them and accepted in their work.

BM: I don't mind the risk. It comes with being an artist. It's another way for human beings to exist. All humans can relate to artistic expression. So you're not so much trying to be yourself as an artist, but allowing yourself to be some sort of filter. I see art as a humanistic endeavor, but it's not easy to understand. Some people try to oversimplify it. What's great about being in New York is that there's a whole audience that really works at understanding it, because New York is a real cultural city—and it's enlightening. It makes your life better. You see yourself as part of the hum.

JL: The drawings are much more expressive now than they were in the 1960s and 1970s, when you were concentrating on the grids and solid graphite forms.

BM: With the grid and the graphite drawings I would refine them and refine

them. I just got to the point where it was more about refining than anything else. I wanted more expression. What I basically did was stop the painting at a certain point and then follow the drawing and then work the drawings up into the paintings, which is how the whole calligraphic idea developed. It took me a while to figure out how to do that.

JL: It was a huge change.

BM: It was really sort of traumatic, but I had a lot of drawing books out as well as drawings I had been making over the years. All of a sudden I would look at them and say, how do I work this into painting? There was a whole group of strange paintings I was trying to get going, and then there was finally one painting that was heading in a certain kind of direction.

JL: Let me just go back to drawings in general for a moment. You make drawings that are important in themselves as well as in their relationship to your paintings.

BM: It seems to me the more fluent the drawing, the more it can express your ideas. One of the things I like about a drawing is that it's a very direct form of expression, whereas a painting becomes an evolved statement because of the materials you're using. It's paint and it's color. You can correct it more; you can refine; you can take it to a different kind of refinement. Whereas a drawing can be very refined just because it's so direct and there's so little between you and the expression. I love how drawing is so close to you. It comes right out of you. My work tends to evolve from this small, direct thing into something bigger. It's very—I don't want to say studied, because that makes it seem too academic. But you're really giving the idea a chance to work itself out by taking it from the simplest to the most complex kind of forms. I've always really loved looking at drawings for that reason.

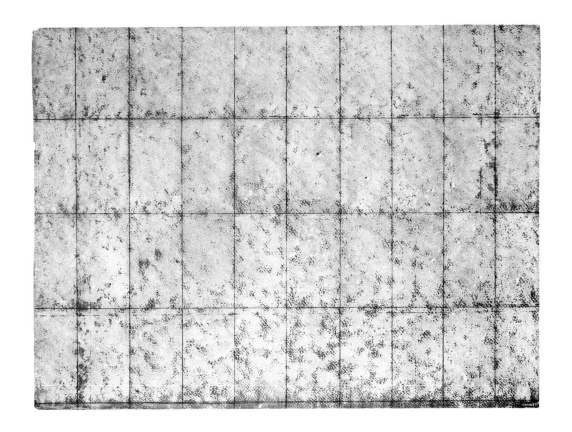

UNTITLED 1964

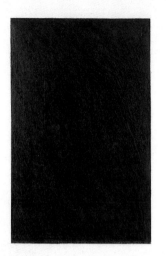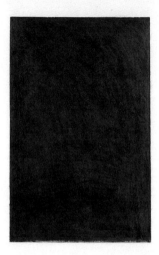

TWO STUDIES, BACK SERIES 1967

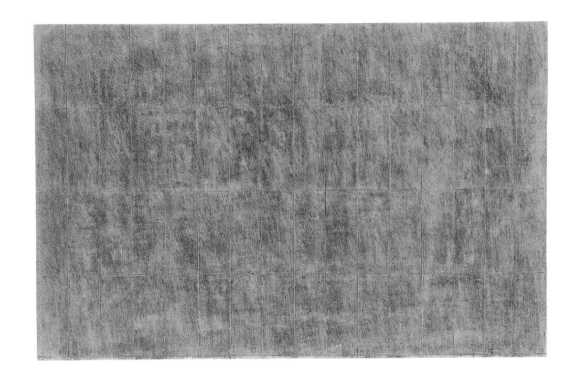

UNTITLED 1968

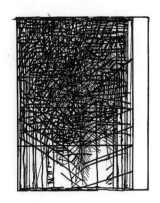

SUICIDE NOTE 1972–73

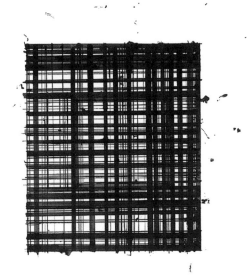

UNTITLED (STICK DRAWING) 1974

HOMAGE TO ART 9 1973

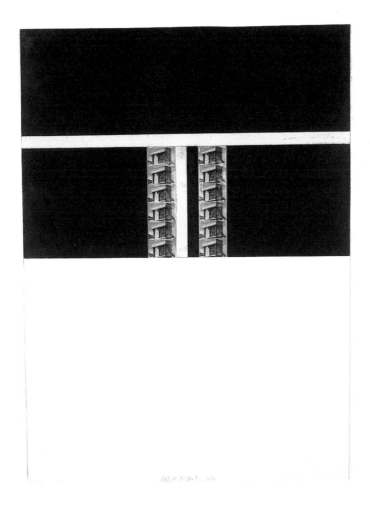

SOUVENIR DE GRÈCE 14 1974 AND 1996

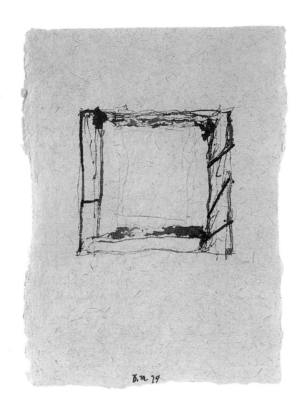

MIRABELLE ADDENDA 2 1979

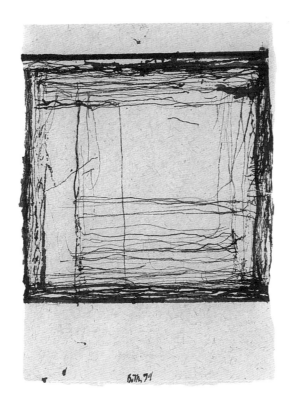

MIRABELLE ADDENDA 3 1979

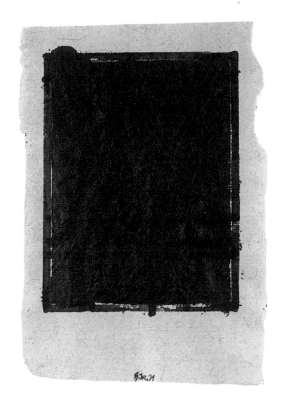

MIRABELLE ADDENDA 6 1979

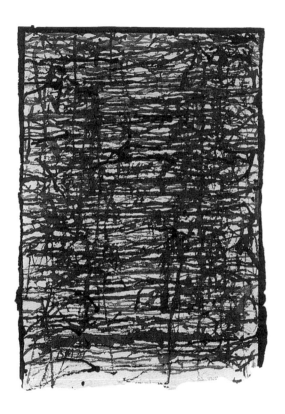

MIRABELLE ADDENDA 9 1979

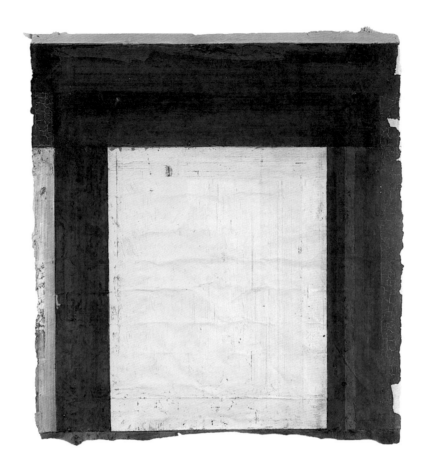

HYDRA GROUP X 1979–81

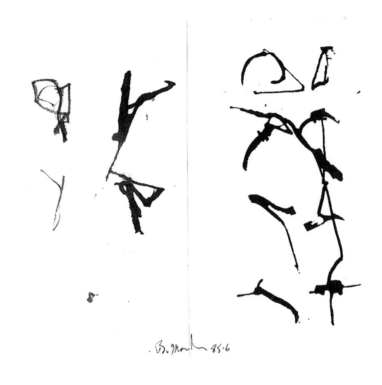

ST. BART'S 1985–86 N.Y. 1 1985–86

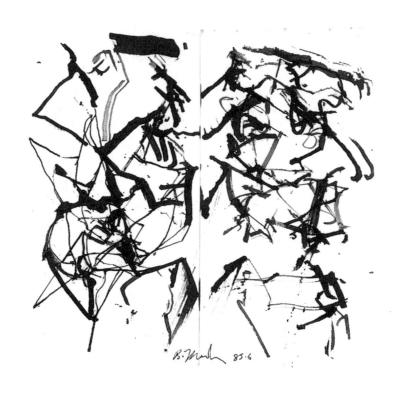

ST. BART'S 1985–86 N.Y. 2 1985–86

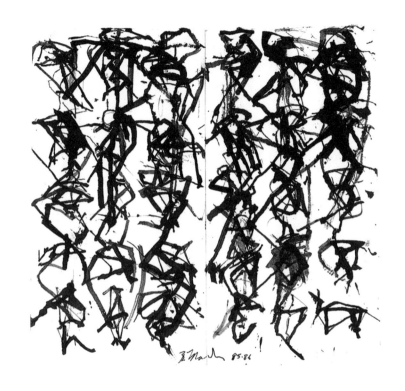

ST. BART'S·1985–86 N.Y. 3 1985–86

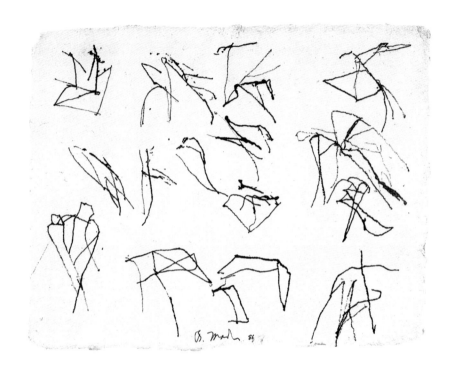

VEGETATION ST. BART'S 1 1986

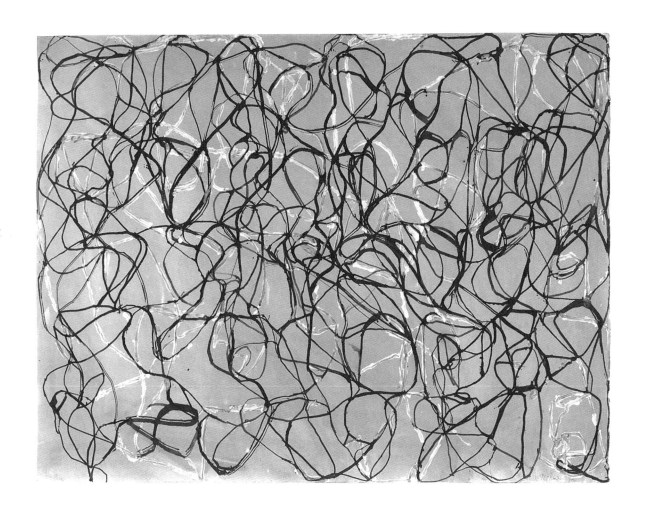

BRIDGE STUDY 1991

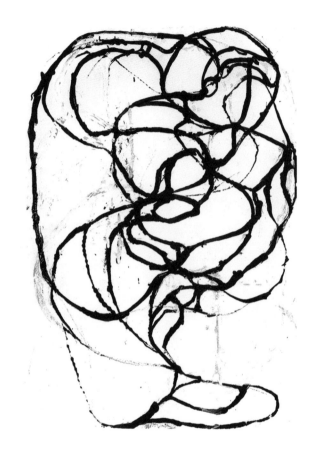

EAGLES MERE SET, 5 1996–97

1 Souvenir souvenir
 Tampere

WORKBOOK—HYDRA, TAMPERE, N.Y.C., BUCKS CO. 1987–88

44

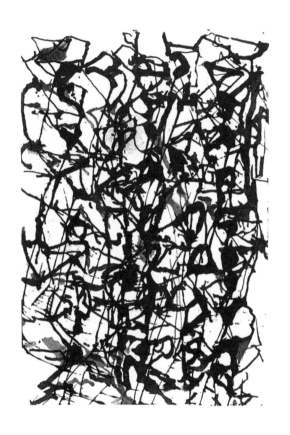

WORKBOOK—HYDRA, TAMPERE, N.Y.C., BUCKS CO. 1987–88

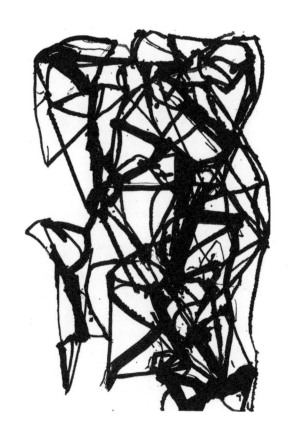

WORKBOOK—HYDRA, TAMPERE, N.Y.C., BUCKS CO. 1987–88

46

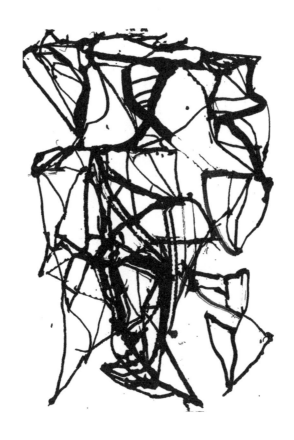

WORKBOOK—HYDRA, TAMPERE, N.Y.C., BUCKS CO. 1987–88

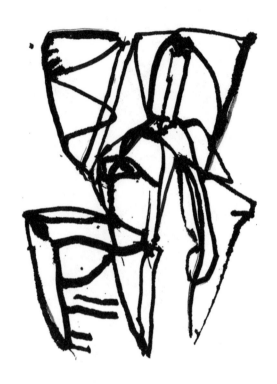

WORKBOOK—HYDRA, TAMPERE, N.Y.C., BUCKS CO. 1987–88

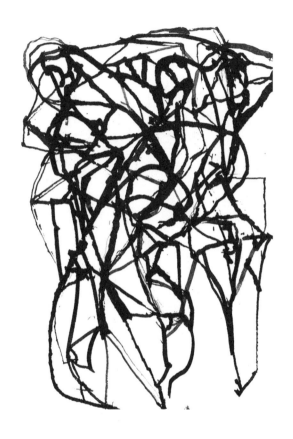

WORKBOOK—HYDRA, TAMPERE, N.Y.C., BUCKS CO. 1987–88

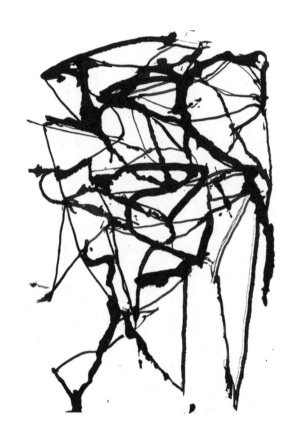

WORKBOOK—HYDRA, TAMPERE, N.Y.C., BUCKS CO. 1987–88

50

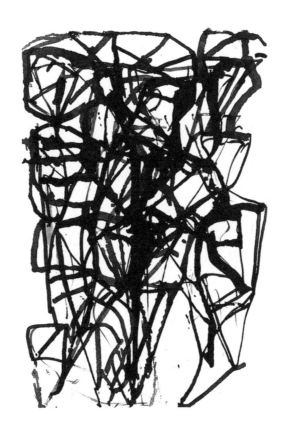

WORKBOOK—HYDRA, TAMPERE, N.Y.C., BUCKS CO. 1987–88

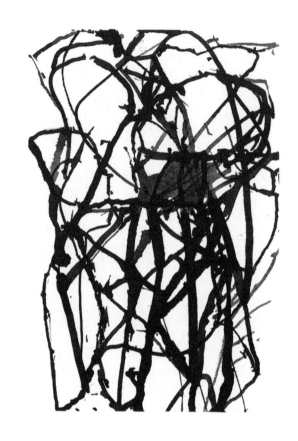

WORKBOOK—HYDRA, TAMPERE, N.Y.C., BUCKS CO. 1987–88

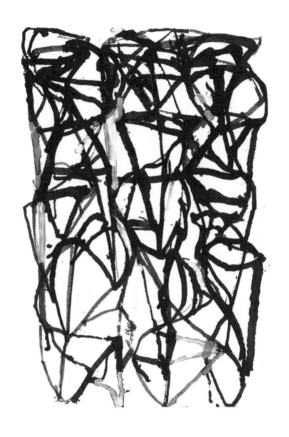

WORKBOOK—HYDRA, TAMPERE, N.Y.C., BUCKS CO. 1987–88

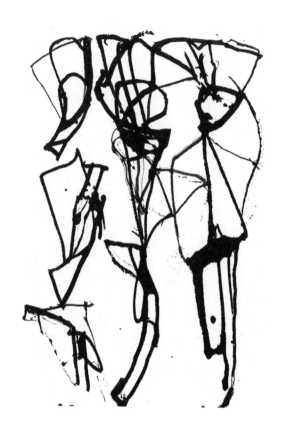

WORKBOOK—HYDRA, TAMPERE, N.Y.C., BUCKS CO. 1987–88

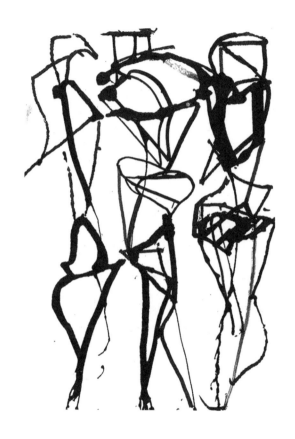

WORKBOOK—HYDRA, TAMPERE, N.Y.C., BUCKS CO. 1987–88

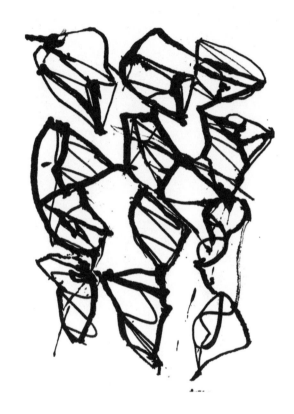

WORKBOOK—HYDRA, TAMPERE, N.Y.C., BUCKS CO. 1987–88

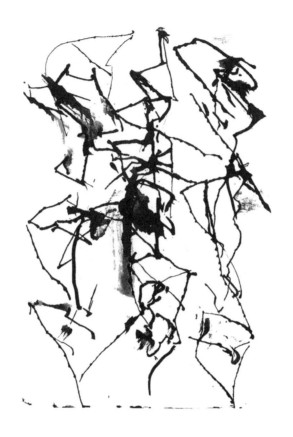

WORKBOOK—HYDRA, TAMPERE, N.Y.C., BUCKS CO. 1987–88

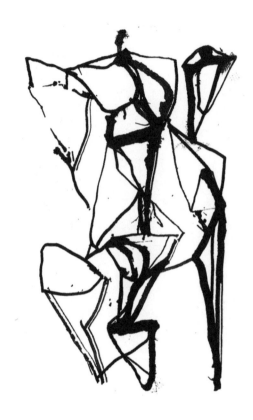

WORKBOOK—HYDRA, TAMPERE, N.Y.C., BUCKS CO. 1987–88

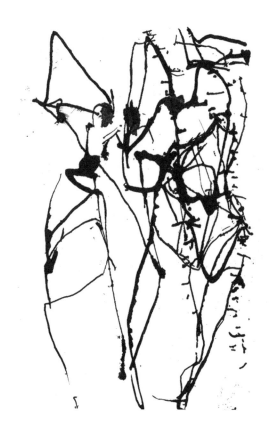

WORKBOOK—HYDRA, TAMPERE, N.Y.C., BUCKS CO. 1987–88

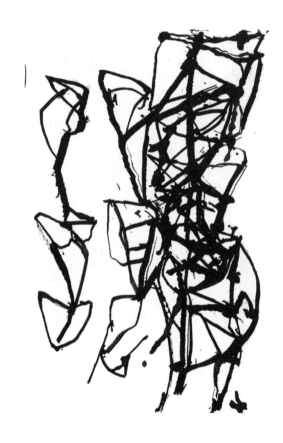

WORKBOOK—HYDRA, TAMPERE, N.Y.C., BUCKS CO. 1987–88

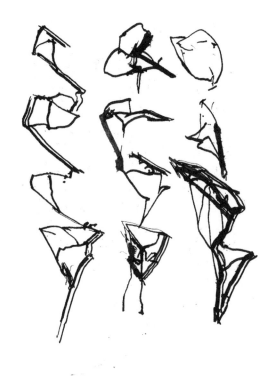

WORKBOOK—HYDRA, TAMPERE, N.Y.C., BUCKS CO. 1987–88

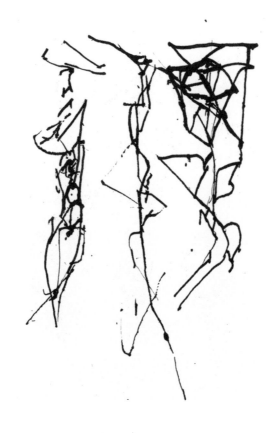

WORKBOOK—HYDRA, TAMPERE, N.Y.C., BUCKS CO. 1987–88

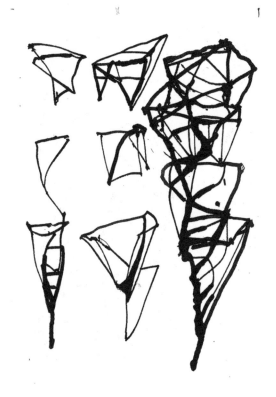

WORKBOOK—HYDRA, TAMPERE, N.Y.C., BUCKS CO. 1987–88

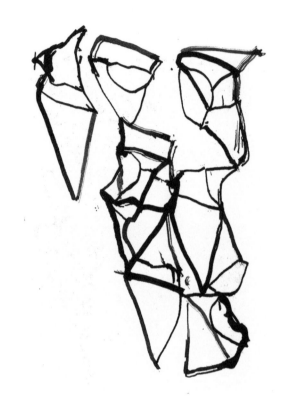

WORKBOOK—HYDRA, TAMPERE, N.Y.C., BUCKS CO. 1987–88

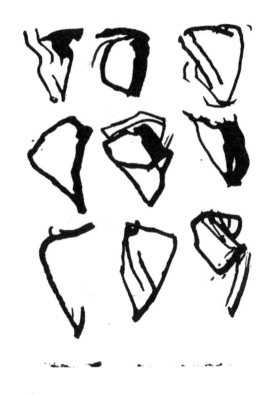

WORKBOOK—HYDRA, TAMPERE, N.Y.C., BUCKS CO. 1987–88

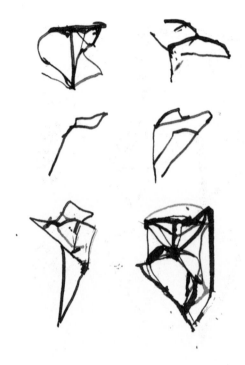

WORKBOOK—HYDRA, TAMPERE, N.Y.C., BUCKS CO. 1987–88

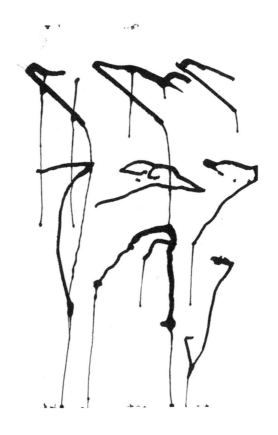

WORKBOOK—HYDRA, TAMPERE, N.Y.C., BUCKS CO. 1987–88

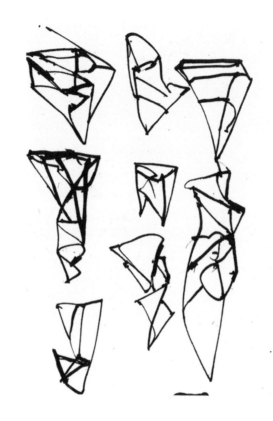

WORKBOOK—HYDRA, TAMPERE, N.Y.C., BUCKS CO. 1987–88

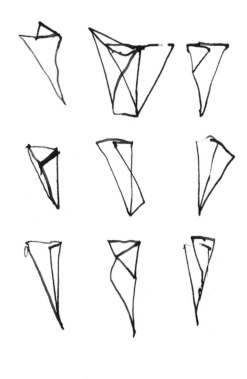

WORKBOOK—HYDRA, TAMPERE, N.Y.C., BUCKS CO. 1987–88

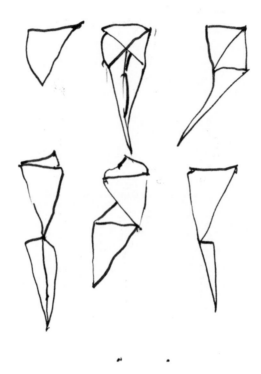

WORKBOOK—HYDRA, TAMPERE, N.Y.C., BUCKS CO. 1987–88

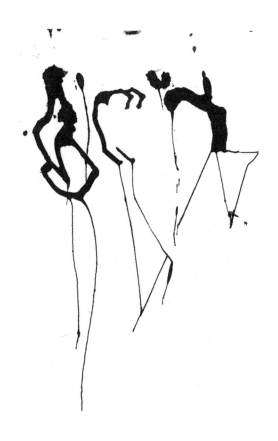

WORKBOOK—HYDRA, TAMPERE, N.Y.C., BUCKS CO. 1987–88

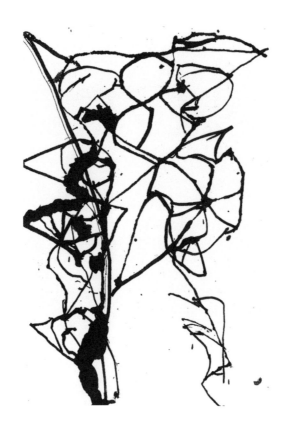

WORKBOOK—HYDRA, TAMPERE, N.Y.C., BUCKS CO. 1987–88

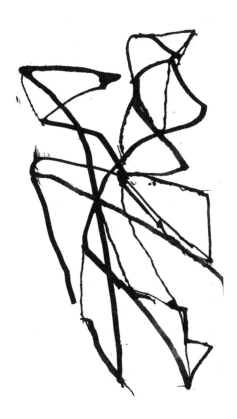

WORKBOOK—HYDRA, TAMPERE, N.Y.C., BUCKS CO. 1987–88

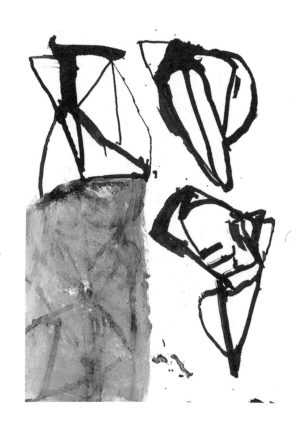

WORKBOOK—HYDRA, TAMPERE, N.Y.C., BUCKS CO. 1987–88

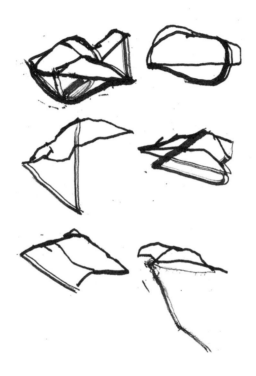

WORKBOOK—HYDRA, TAMPERE, N.Y.C., BUCKS CO. 1987–88

WORKBOOK—HYDRA, TAMPERE, N.Y.C., BUCKS CO. 1987–88

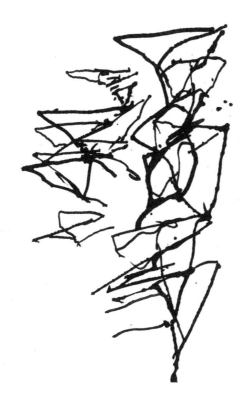

WORKBOOK—HYDRA, TAMPERE, N.Y.C., BUCKS CO. 1987–88

WORKS IN THE EXHIBITION

Dimensions are in inches followed by centimeters; height precedes width.

All works are in the Permanent Collection of the Whitney Museum of American Art, New York.

UNTITLED 1964
Charcoal on paper, 21 1/2 x 29 1/2 (54.6 x 74.9)
Purchase, with funds from The Lauder Foundation,
Evelyn and Leonard Lauder Fund for the Acquisition of Master Drawings 97.124

TWO STUDIES, BACK SERIES 1967
Graphite, beeswax, and black chalk on paper, 22 5/16 x 31 (56.7 x 78.7)
Purchase, with funds from The Lauder Foundation,
Evelyn and Leonard Lauder Fund for the Acquisition of Master Drawings
and the Drawing Committee 97.108.10

UNTITLED 1968
Beeswax, graphite, oil crayon, and pastel on paper, 22 x 31 1/2 (55.9 x 80)
Given in memory of Hermon More by four of his friends 69.16

SUICIDE NOTE 1972–73
Ink on paper, 11 5/8 x 7 3/4 (29.5 x 19.7)
Purchase, with funds from The Lauder Foundation,
Evelyn and Leonard Lauder Fund for the Acquisition of Master Drawings
and the Drawing Committee 97.108.11

HOMAGE TO ART 9 1973
Graphite, beeswax, and collage on paper, 30 x 22 1/2 (76.2 x 57.2)
Purchase with funds from The Aaron I. Fleischman Foundation and promised gift
of Aaron I. Fleischman P.2.98

UNTITLED (STICK DRAWING) 1974
Ink on paper, 13 13/16 x 16 7/8 (35.1 x 42.9)
Purchase, with funds from The Lauder Foundation,
Evelyn and Leonard Lauder Fund for the Acquisition of Master Drawings
and the Drawing Committee 97.108.12

SOUVENIR DE GRÈCE 14 1974 AND 1996
Graphite, beeswax, and collage on paper, 29 5/8 x 22 1/4 (75.2 x 56.5)
Purchase, with funds from The Lauder Foundation,
Evelyn and Leonard Lauder Fund for the Acquisition of Master Drawings
and the Drawing Committee 97.108.14

MIRABELLE ADDENDA 2 1979
Ink on handmade paper, 9 1/4 x 7 1/4 (23.5 x 18.4)
Gift of the artist 98.35.1

MIRABELLE ADDENDA 3 1979
Ink on handmade paper, 9 1/4 x 6 3/4 (23.5 x 17.1)
Gift of the artist 98.35.2

MIRABELLE ADDENDA 6 1979
Ink on handmade paper, 9 1/4 x 6 3/4 (23.5 x 17.1)
Gift of the artist 98.35.3

MIRABELLE ADDENDA 9 1979
Ink on handmade paper, 9 1/4 x 6 3/4 (23.5 x 17.1)
Gift of the artist 98.35.4

HYDRA GROUP X 1979–81
Oil on paper, 20 x 18 1/2 (50.8 x 47)
Purchase, with funds from The Lauder Foundation,
Evelyn and Leonard Lauder Fund for the Acquisition of Master Drawings 97.107

ST. BART'S 1985–86 N.Y. 1 1985–86
Ink and gouache on paper, 7 1/4 x 7 3/4 (18.4 x 19.7)
Gift of the artist 98.35.5

ST. BART'S 1985–86 N.Y. 2 1985–86
Ink and gouache on paper, 7 5/16 x 7 3/4 (18.6 x 19.7)
Gift of the artist 98.35.6

ST. BART'S 1985–86 N.Y. 3 1985–86
Ink and gouache on paper, 7 5/16 x 7 7/8 (18.6 x 20)
Gift of the artist 98.35.7

VEGETATION ST. BART'S 1 1986
Ink on paper, 10 1/8 x 13 (25.7 x 33)
Purchase, with funds from The Lauder Foundation,
Evelyn and Leonard Lauder Fund for the Acquisition of Master Drawings
and the Drawing Committee 97.108.13

WORKBOOK—HYDRA, TAMPERE, N.Y.C., BUCKS CO. 1987–88
Ink and gouache on paper, 34 sheets: 6 x 4 1/8 (15.2 x 10.5) each
Gift of the artist 98.49.1–34

BRIDGE STUDY 1991
Ink and gouache on paper, 26 15/16 x 34 7/16 (68.4 x 87.5)
Purchase, with funds from the Drawing Committee and
The Norman and Rosita Winston Foundation, Inc. 92.27

EAGLES MERE SET, 5 1996–97
Ink and gouache on paper, 17 3/4 x 12 1/2 (45.1 x 31.8)
Purchase, with funds from The Lauder Foundation,
Evelyn and Leonard Lauder Fund for the Acquisition of Master Drawings
and the Drawing Committee 97.108.15

"Brice Marden Drawings: The Whitney Museum of American Art Collection" was organized by Janie C. Lee, Adjunct Curator, Drawings, Whitney Museum of American Art, with the assistance of Sarah Buttrick *and* Stacey Schmidt.

This publication was produced by the Publications Department at the Whitney Museum.
Mary E. DelMonico, *Head, Publications*
PRODUCTION: Nerissa Dominguez Vales, *Production Manager*; Christina Grillo, *Publications Assistant*; Sarah Newman, *Production Assistant*
EDITORIAL: Sheila Schwartz, *Editor*; Dale Tucker, *Copy Editor*; Susan Richmond, *Production Coordinator/Editorial Assistant*; Jessica Royer, *Intern*
DESIGN: Catalogue design, Deborah Littlejohn, *Senior Graphic Designer*; Roy Brooks, *Graphic Designer*

PRINTING: Richter Verlag Düsseldorf
Printed and bound in Germany
PHOTOGRAPH AND REPRODUCTION CREDITS: Geoffrey Clements, *25–29, 31–42, 45, 66, 67, 69–71, 76*; Sheldan C. Collins, *44, 46–65, 68, 72–75, 77*; ©1993 David Seidner, *cover, frontispiece, 9, 12*

ISBN 0-87427-120-7 (Whitney)
ISBN 0-8109-6828-2 (Abrams)

Library of Congress Cataloging-in-Publication Data
Lee, Janie C.
 Brice Marden Drawings: The Whitney Museum of American Art Collection/Janie C. Lee
 p. cm.
 Published to accompany the exhibition of the same name at the Whitney Museum of American Art.
 ISBN 0-87427-120-7 (paper: alk. paper)
 1. Marden, Brice, 1938– —Exhibitions. 2. Drawing–New York (State)–New York–Exhibitions.
 3. Whitney Museum of American Art–Exhibitions. I. Whitney Museum of American Art. II. Lee, Janie C.
 III. Title.

NC139.M26A 1998 98-41430
741.973—dc21 CIP

©1998 Whitney Museum of American Art
945 Madison Avenue, New York, NY 10021